Magical Mehndi Designs

COLORING BOOK

Striking Patterns on a Dramatic Black Background

LINDSEY BOYLAN

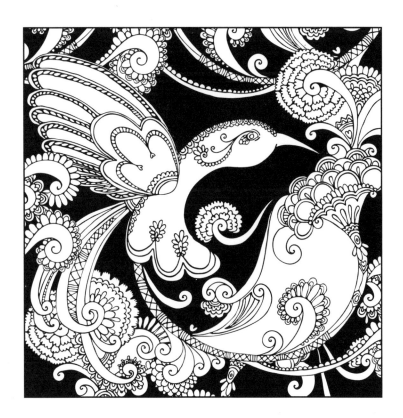

DOVER PUBLICATIONS, INC.
MINEOLA, NEW YORK

Derived from the ancient art of henna body painting, thirty-one designs offer exciting coloring challenges. The illustrations—featuring exotic birds and butterflies, swirling paisley prints, and fabulous flowers—are printed on a black background that creates a dramatic effect. Plus, the pages are perforated and are printed on one side only for easy removal and display.

Bibliographical Note

Magical Mehndi Designs Coloring Book: Striking Patterns on a Dramatic Black Background is a new work, first published by Dover Publications, Inc., in 2016.

International Standard Book Number

ISBN-13: 978-0-486-80655-6
ISBN-10: 0-486-80655-3

Manufactured in the United States by RR Donnelley
80655301 2016
www.doverpublications.com

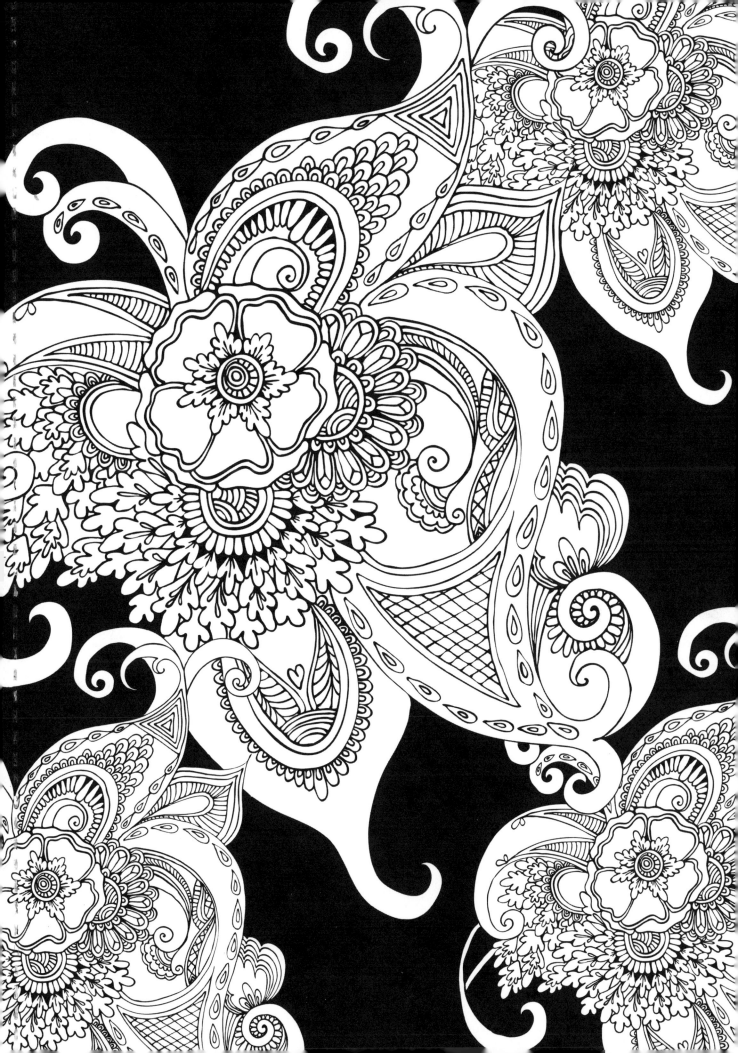

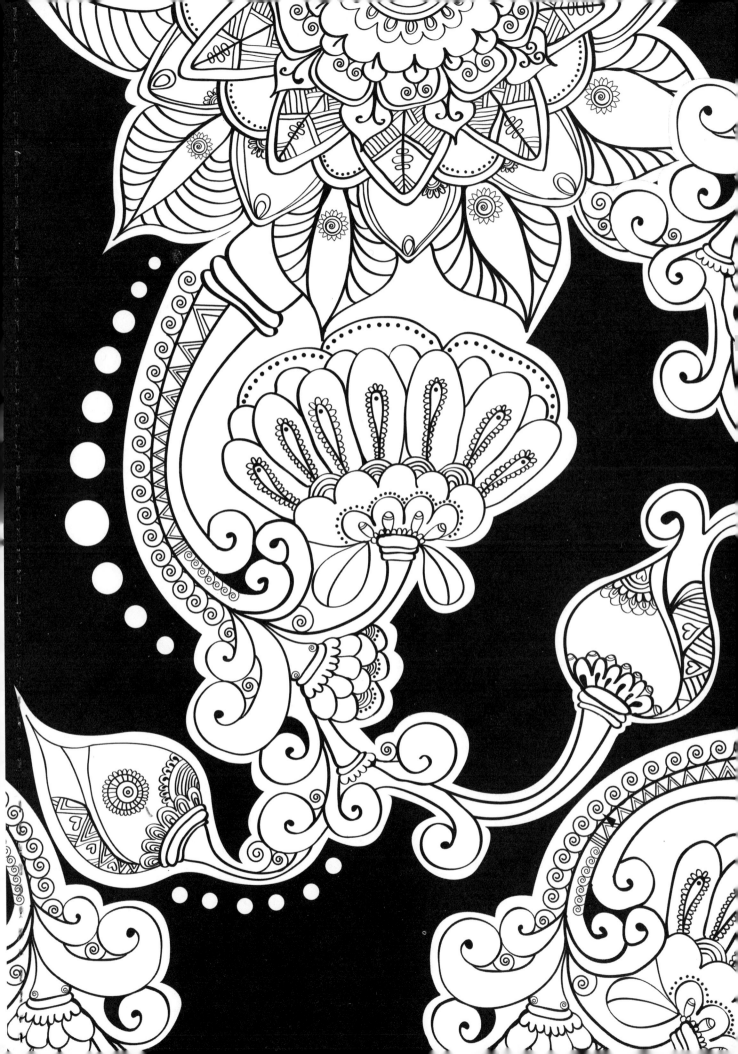

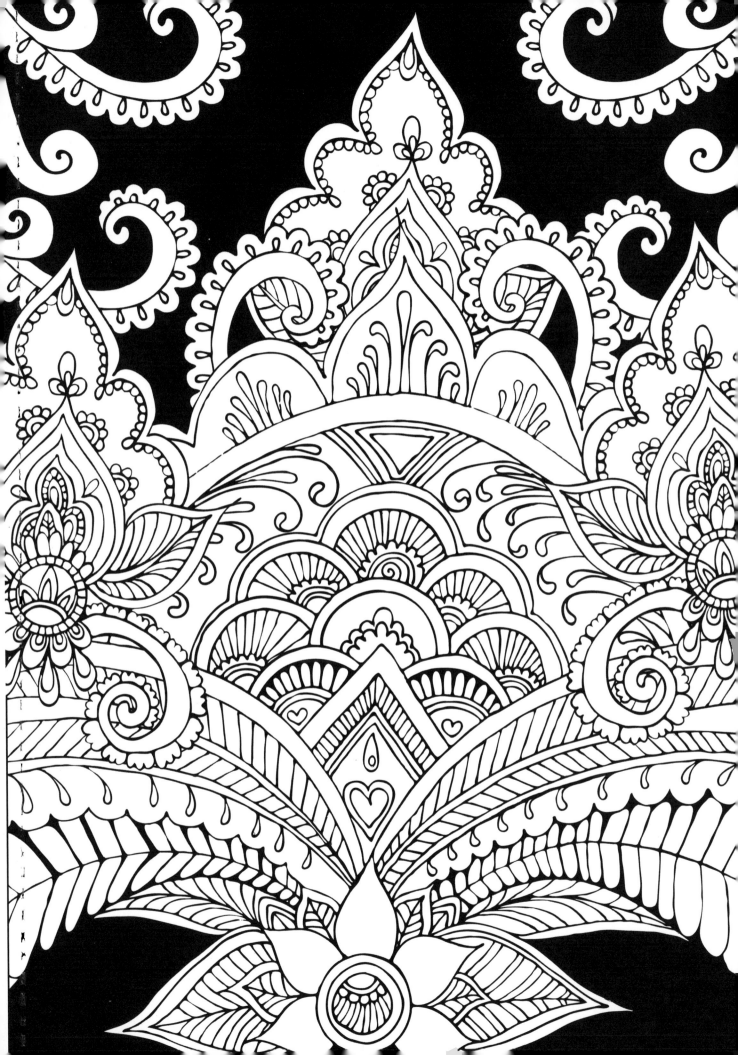

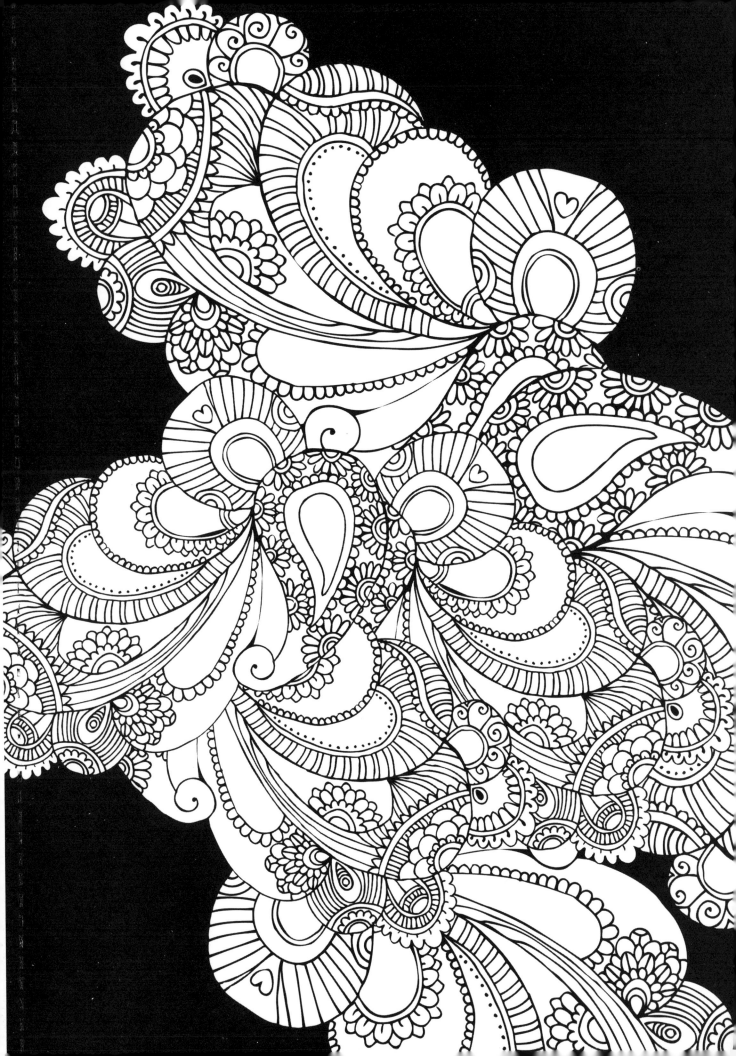

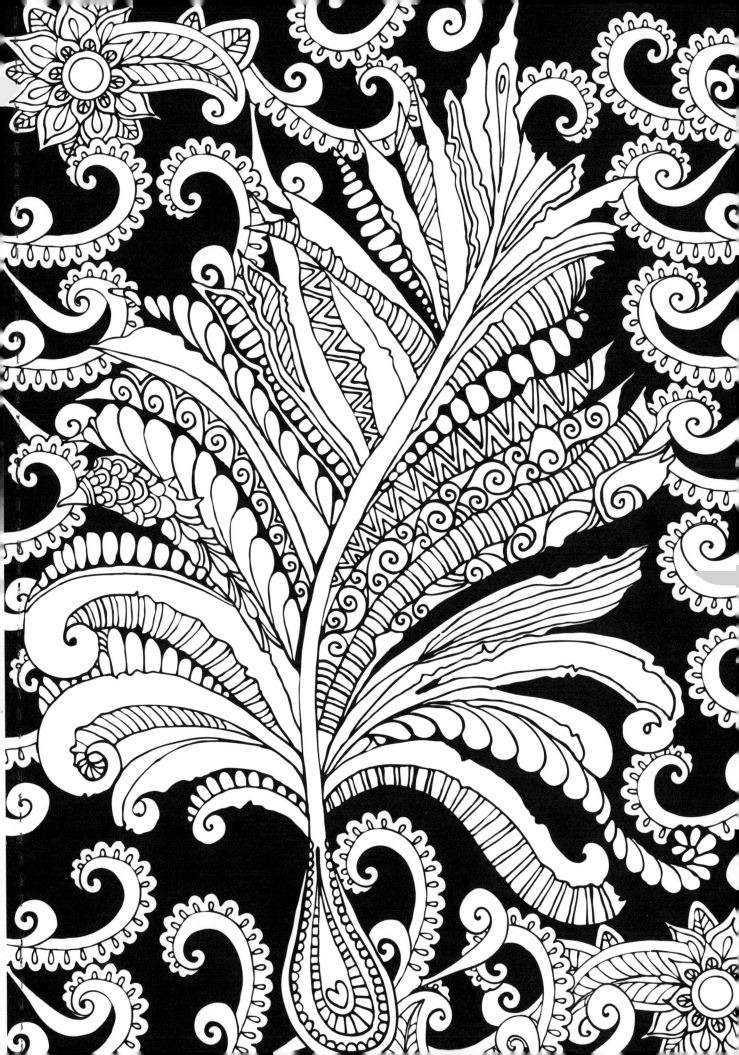

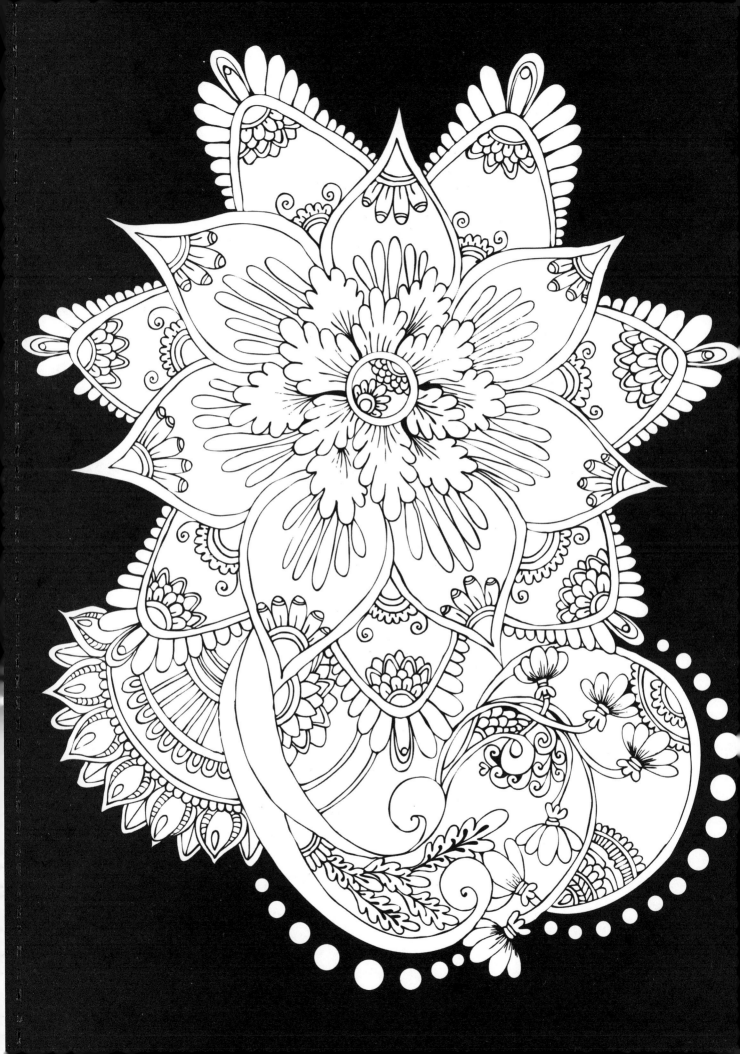

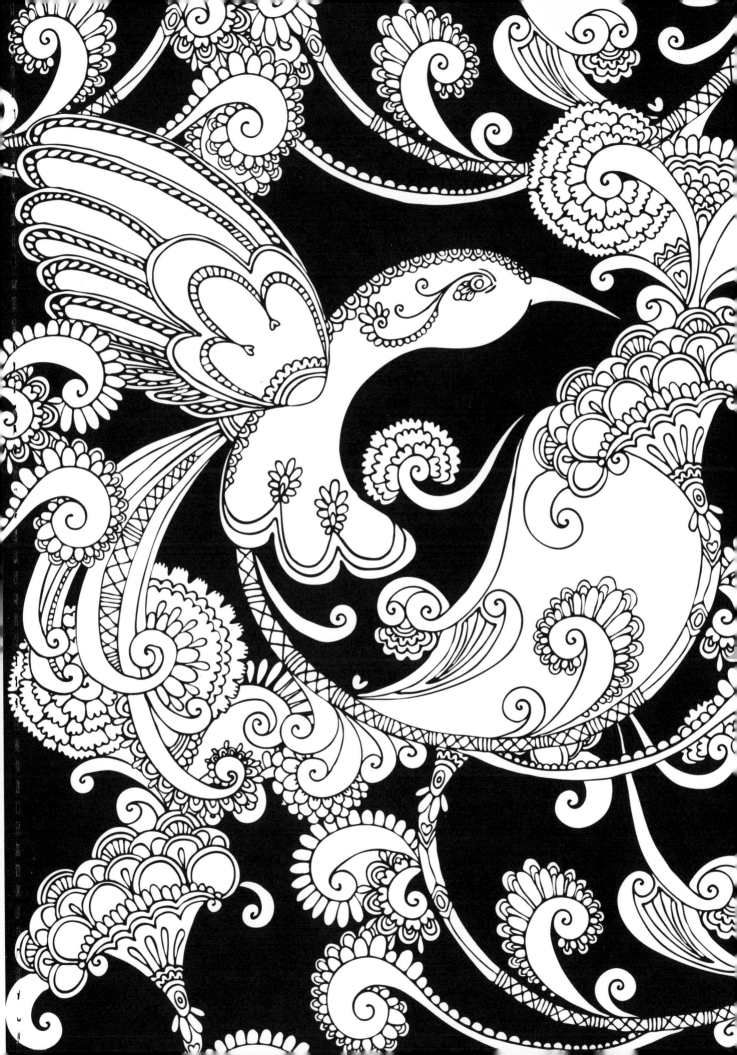

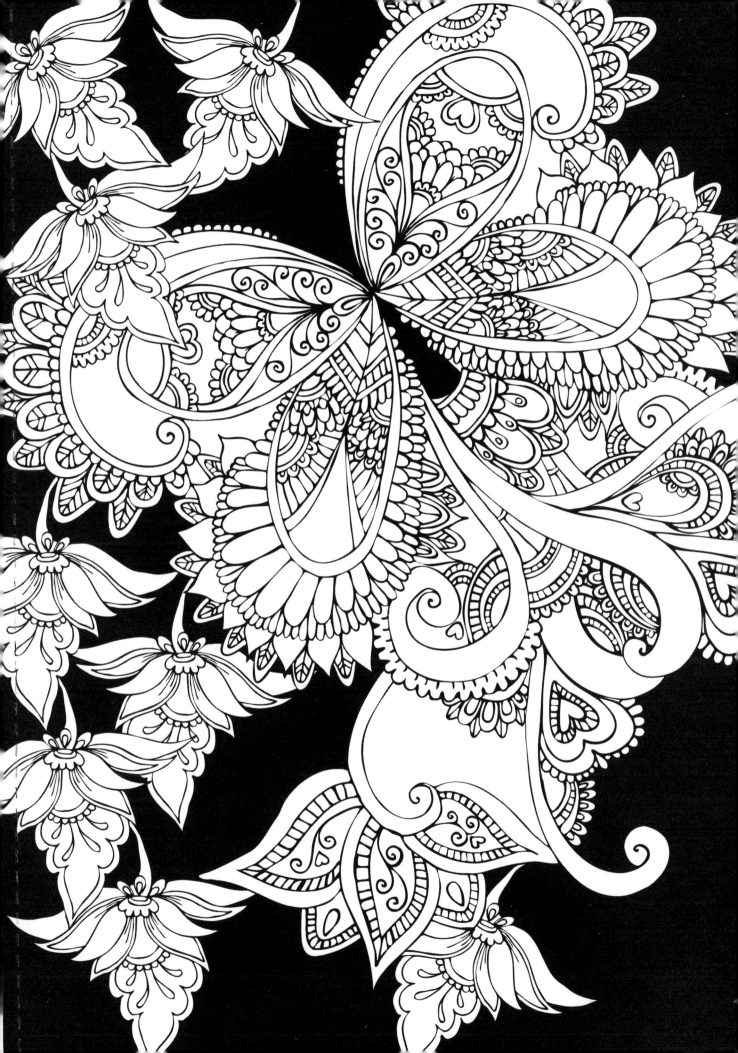

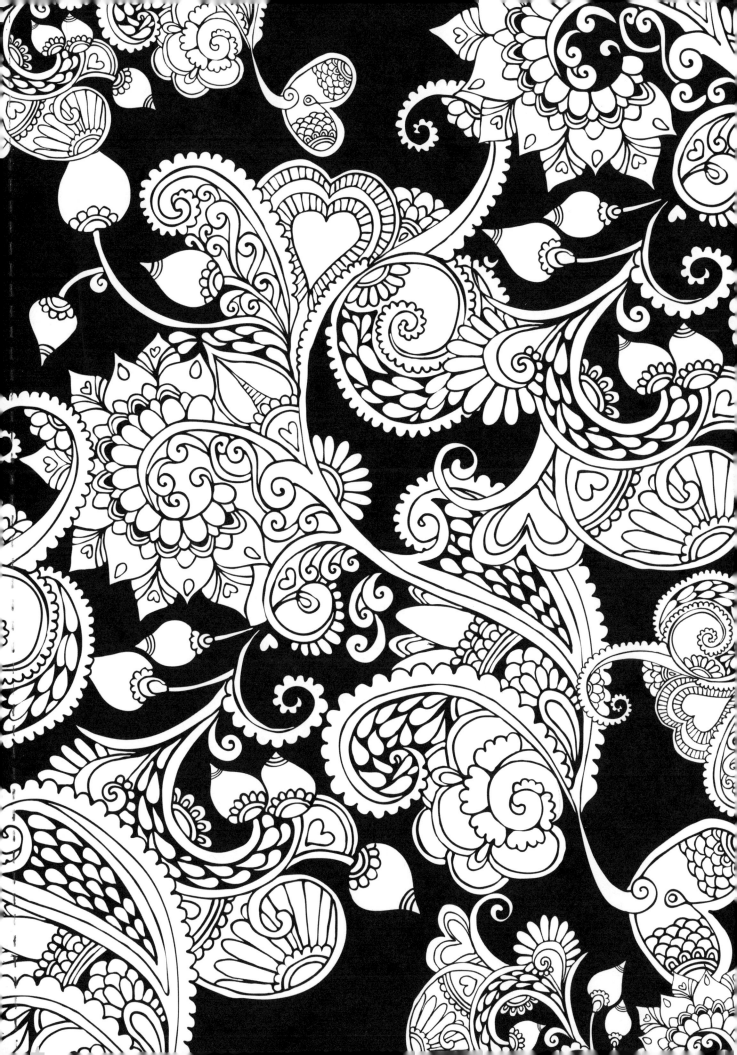

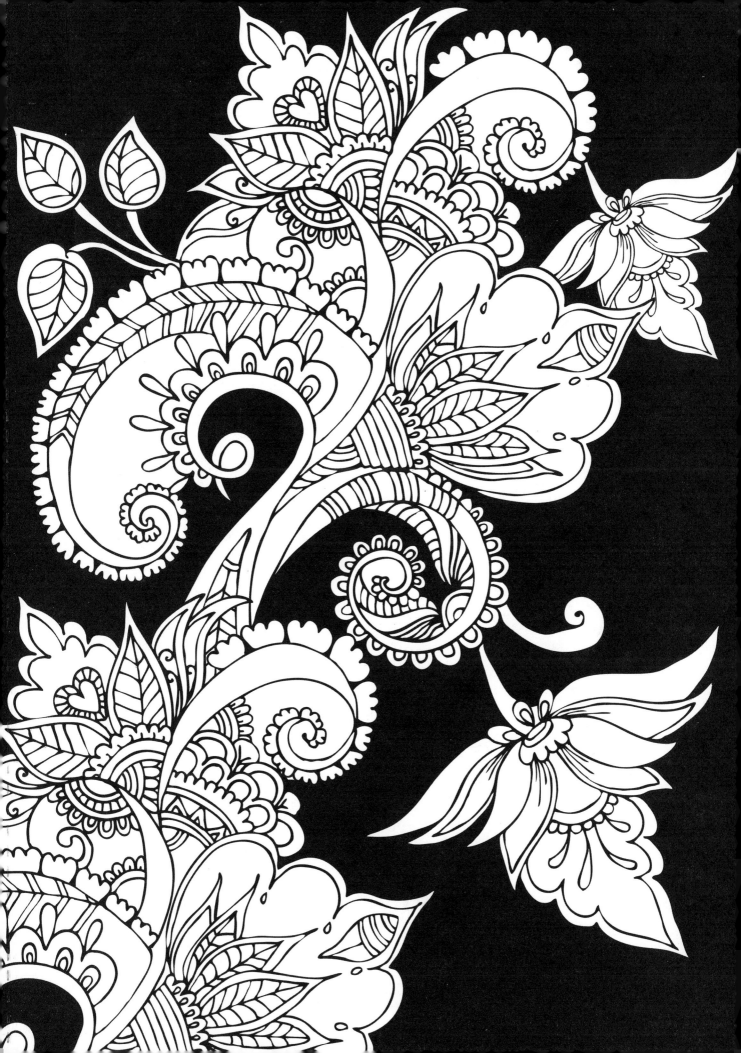

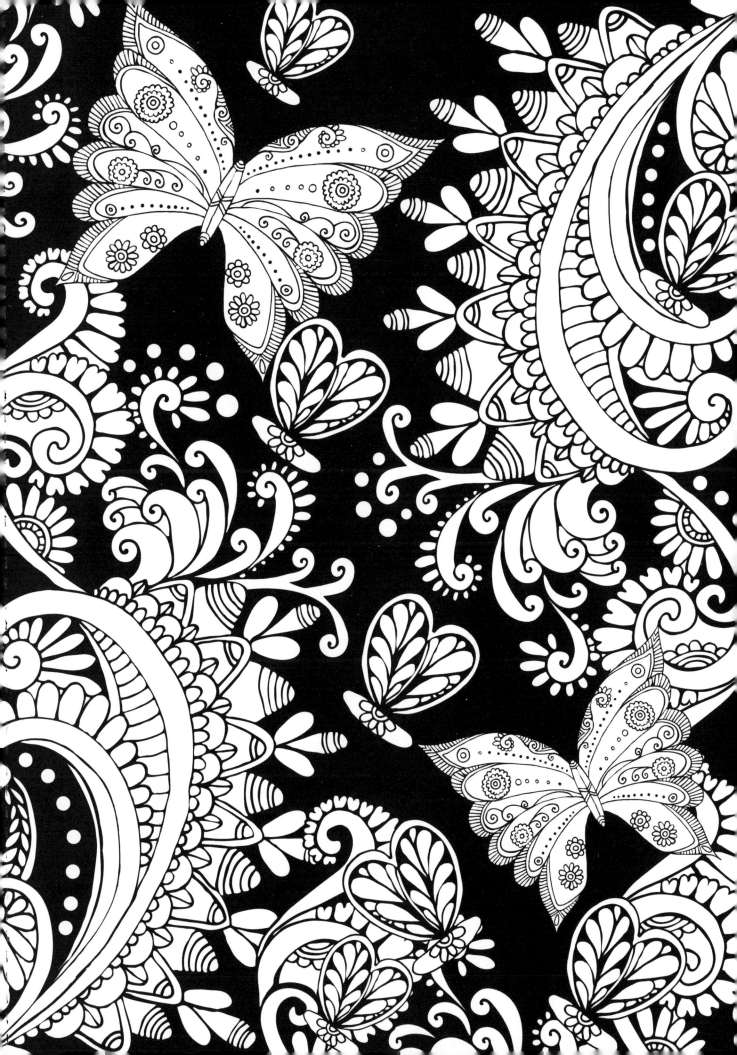

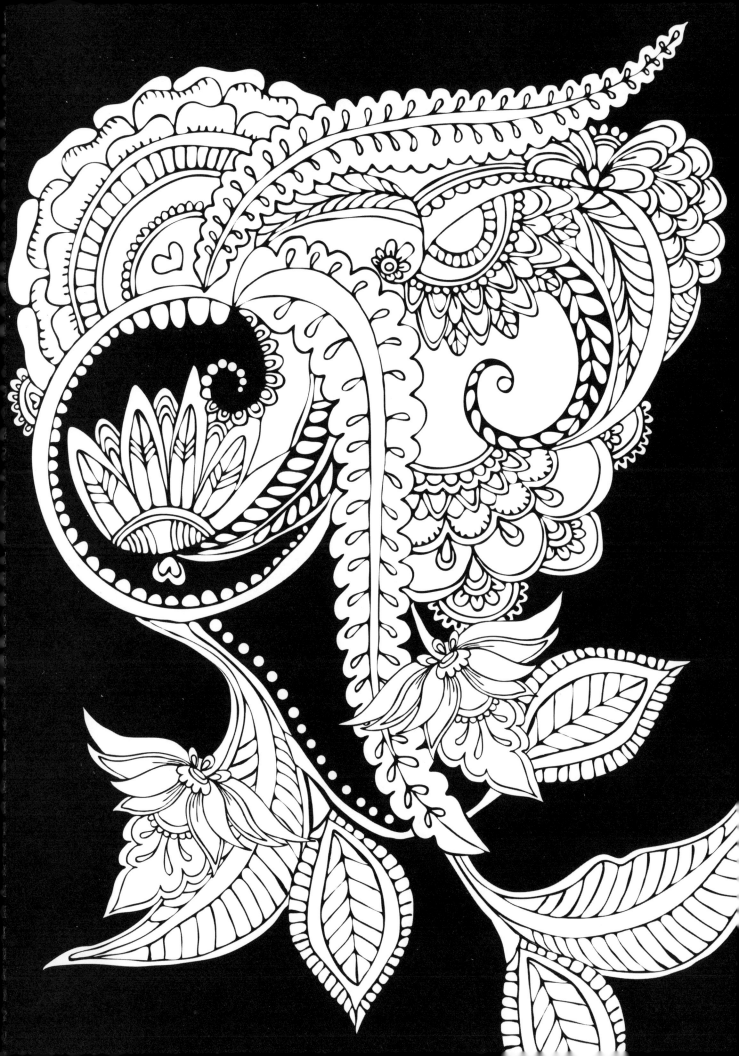

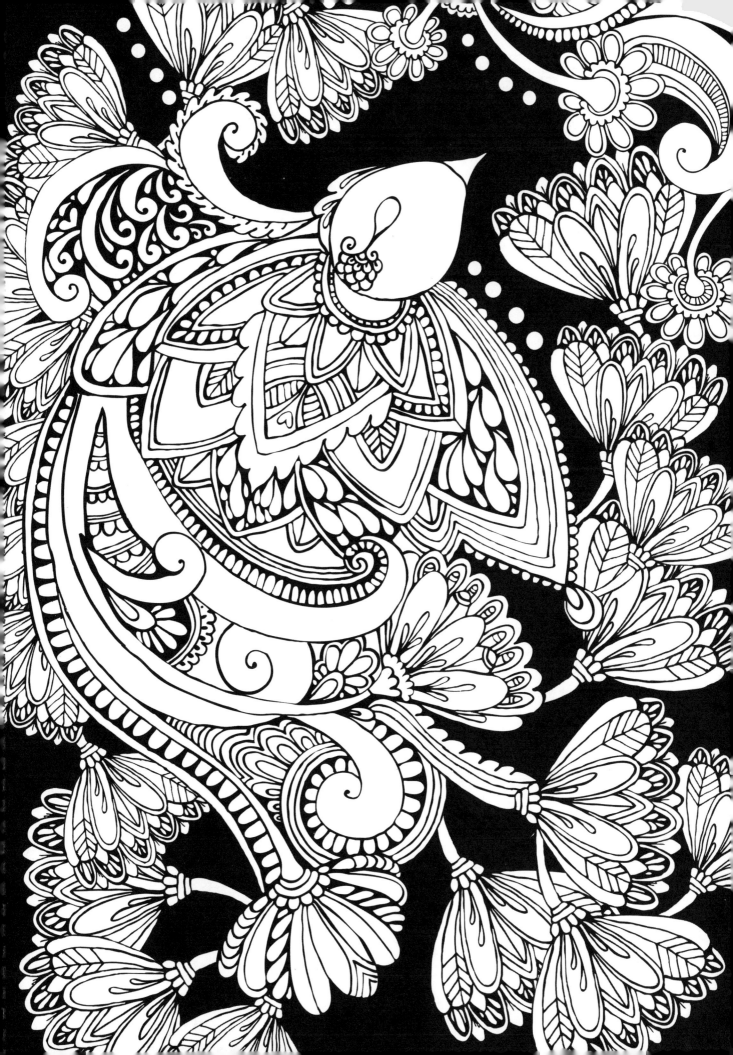

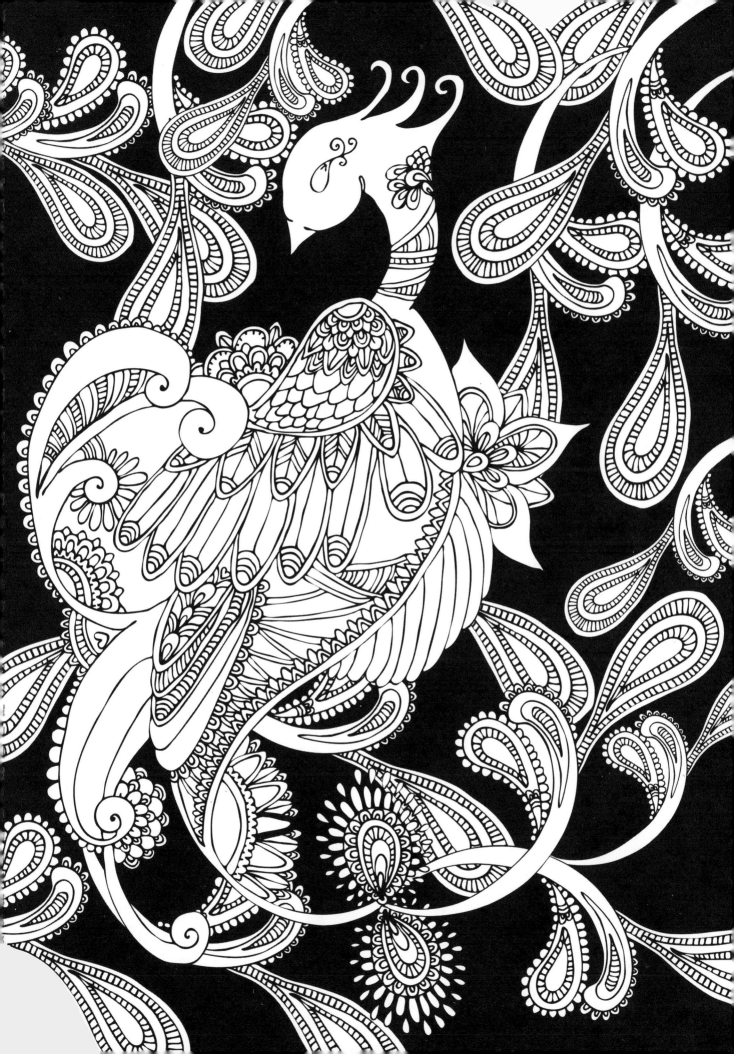

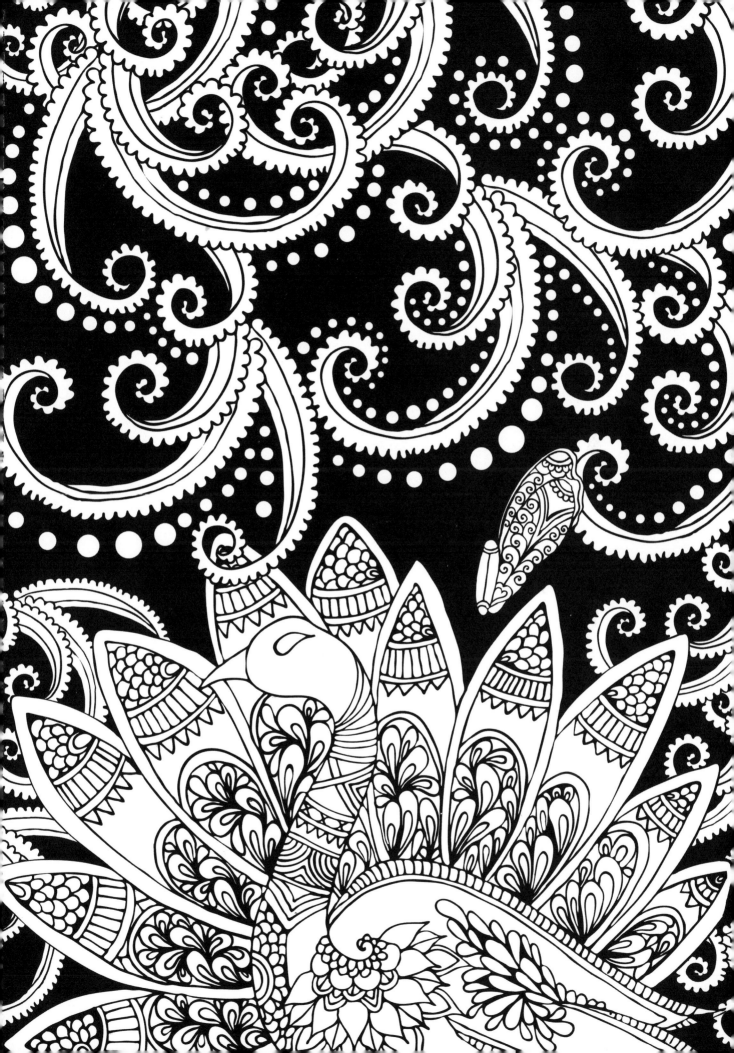

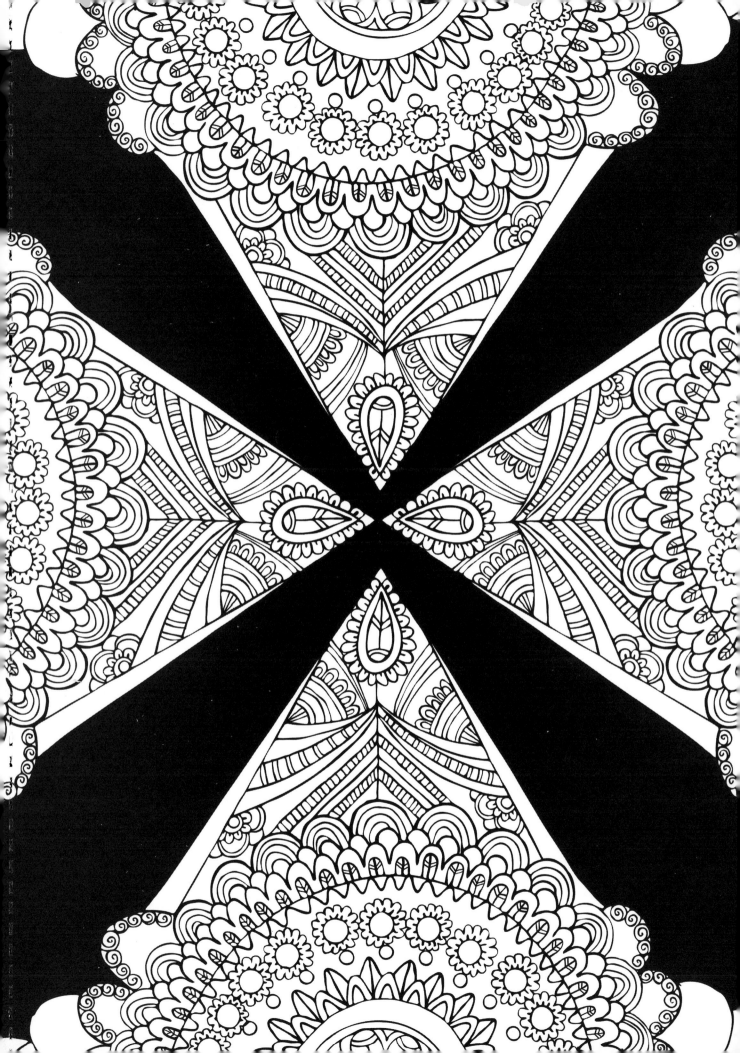

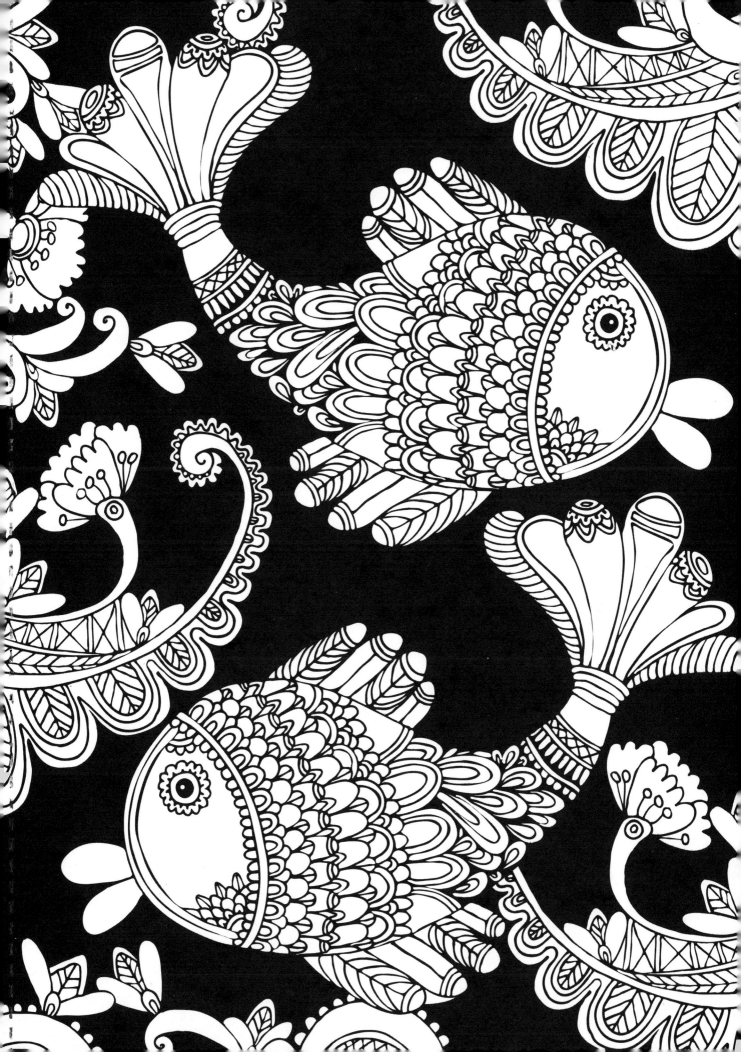

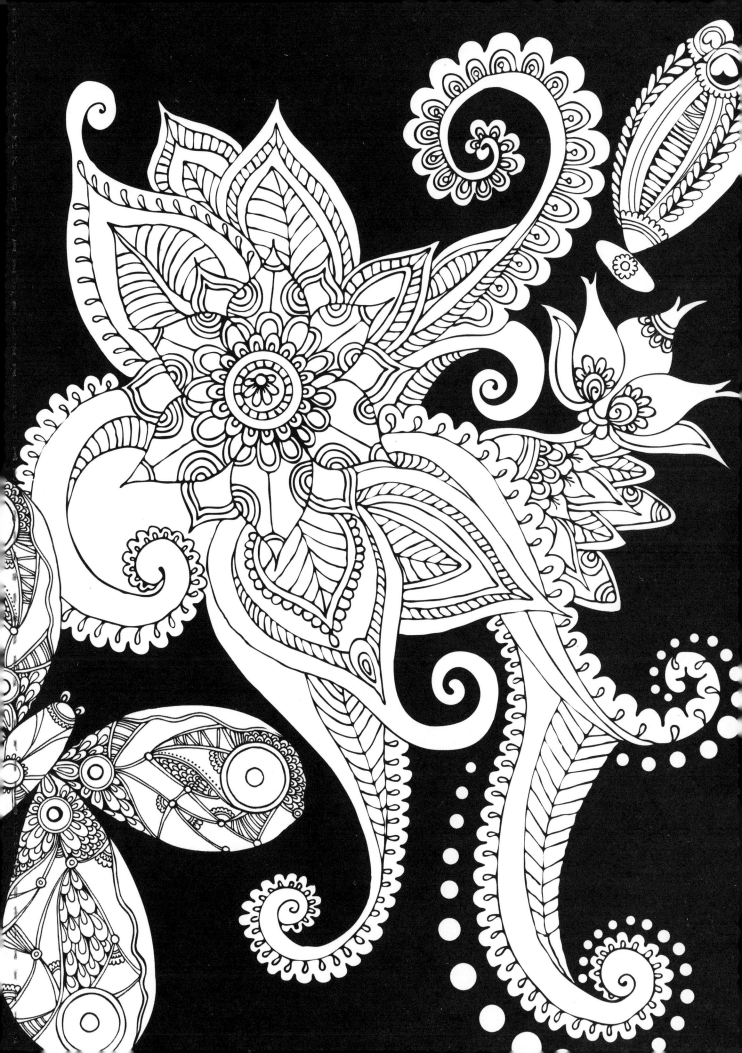

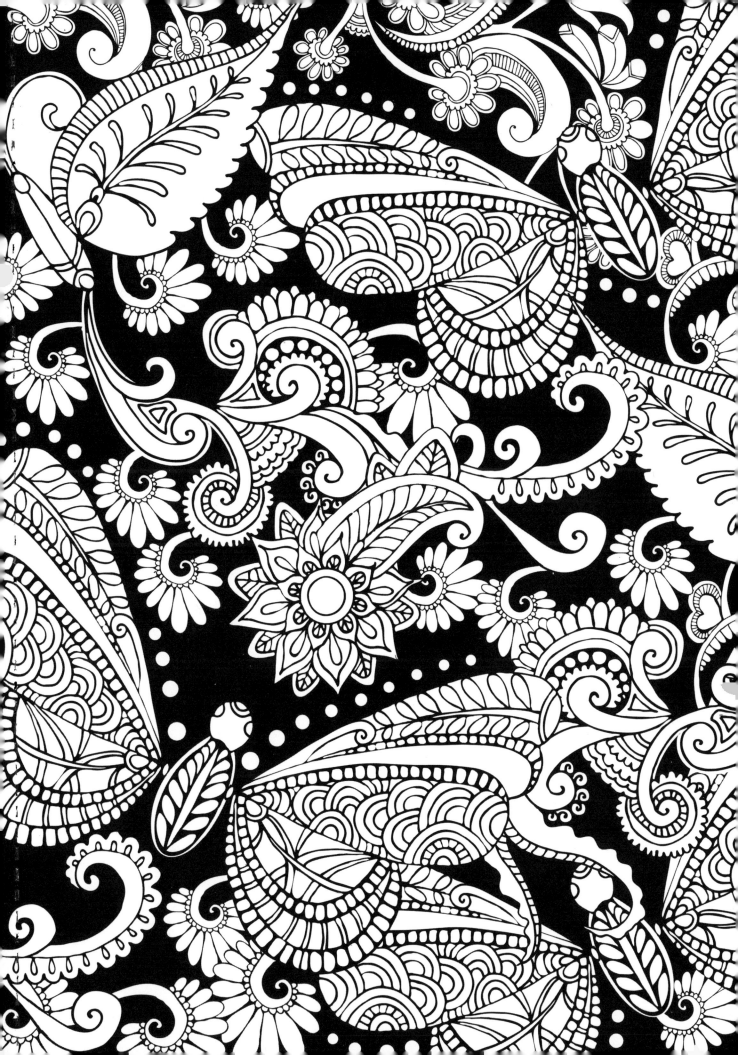

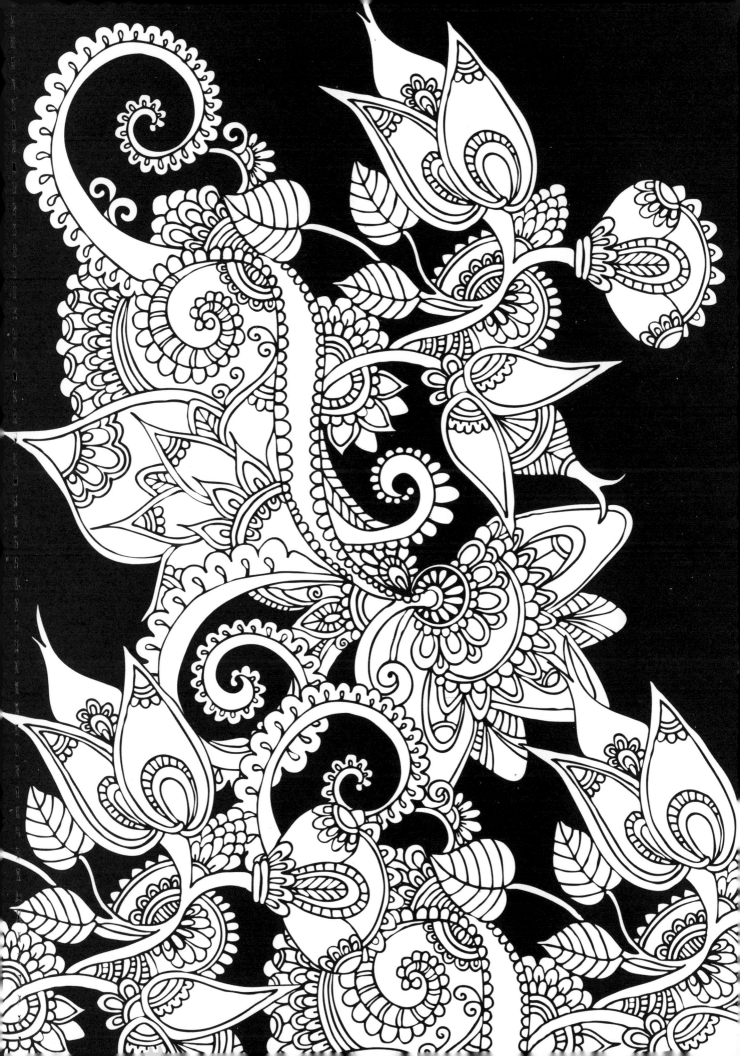

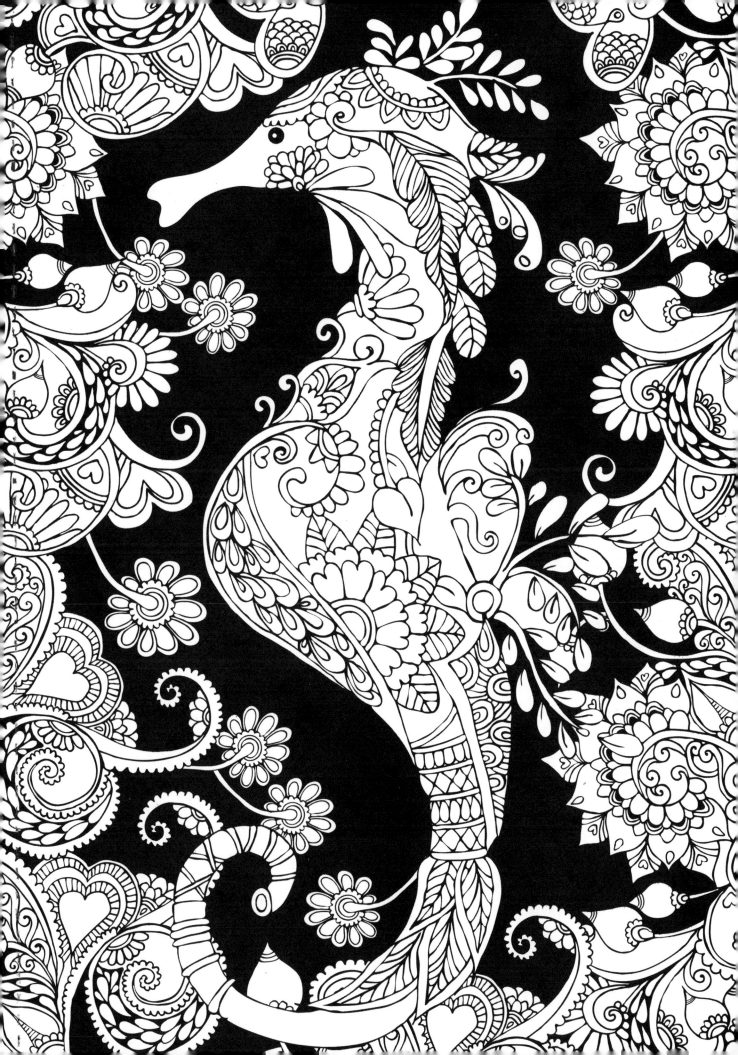

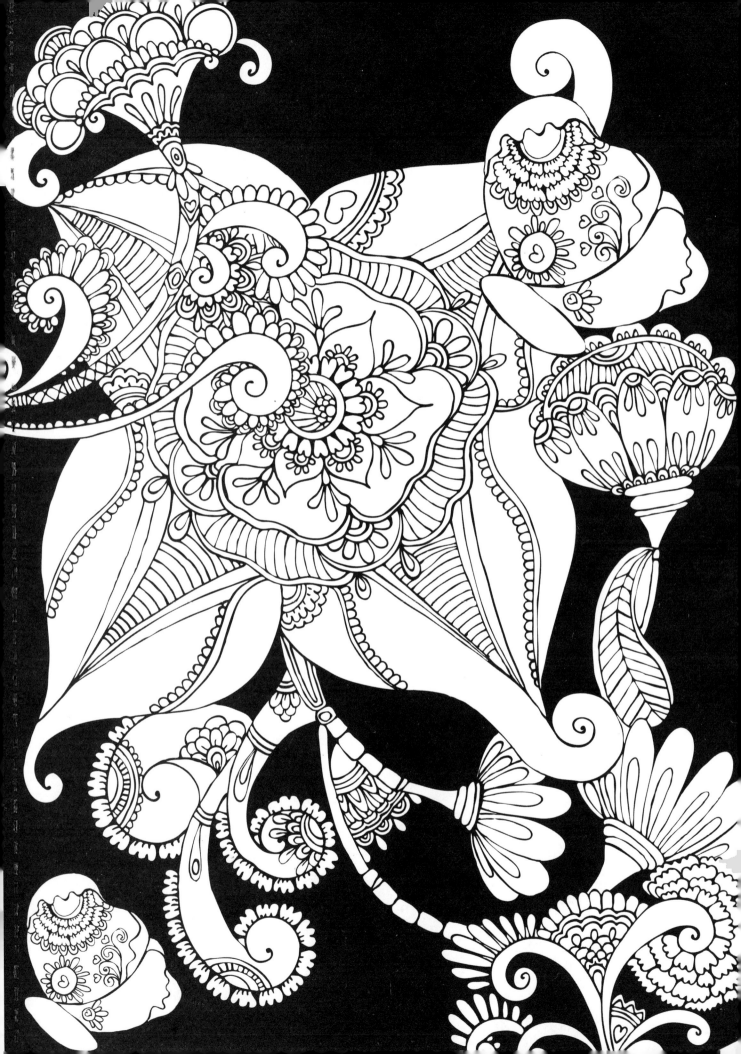

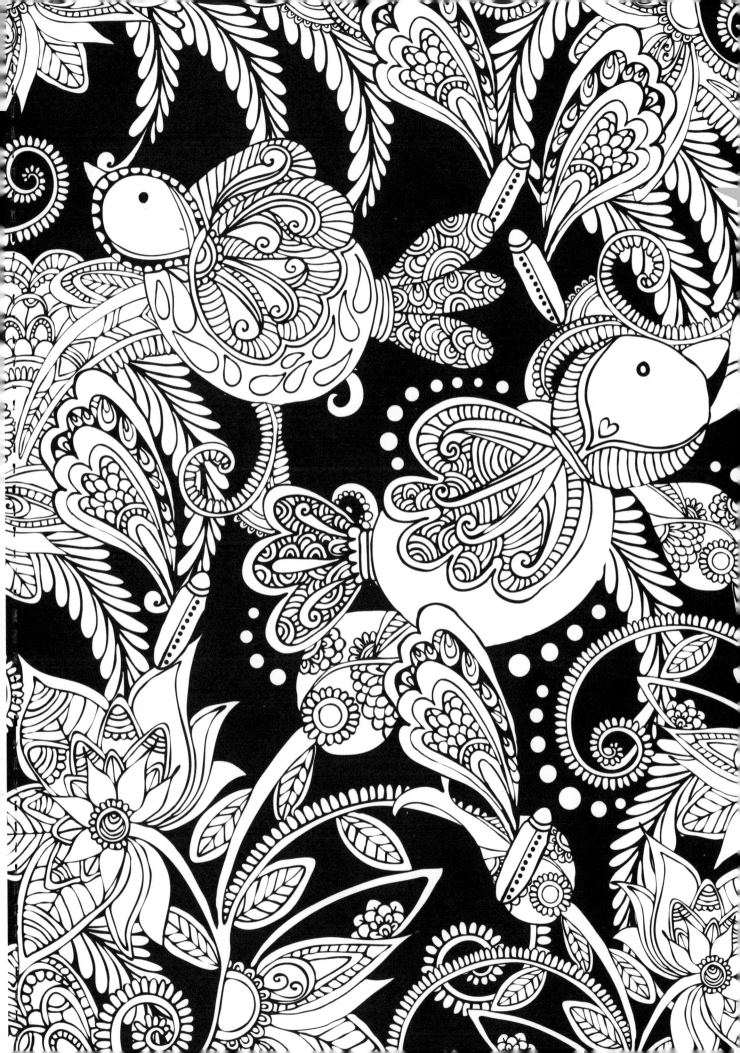

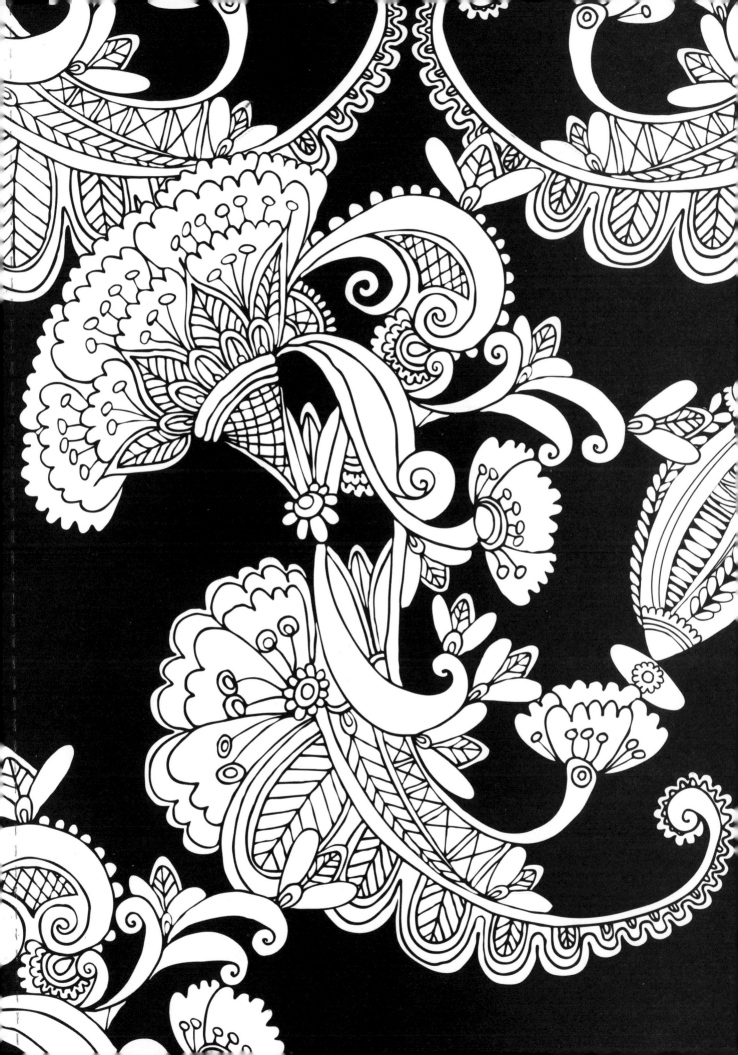

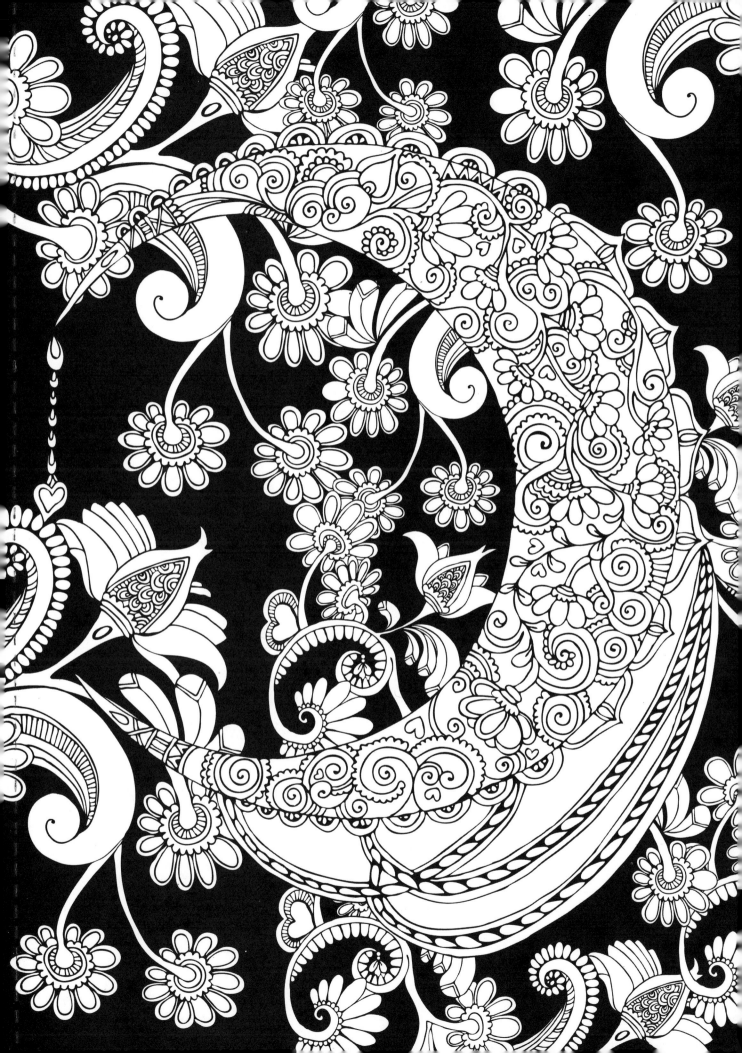

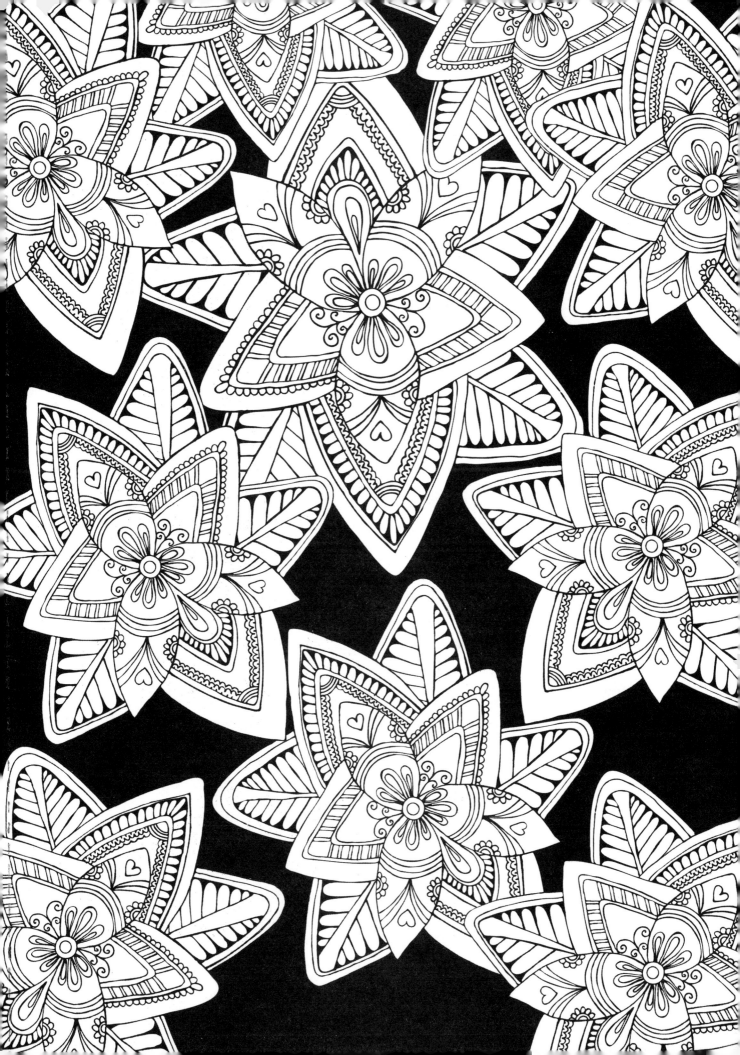

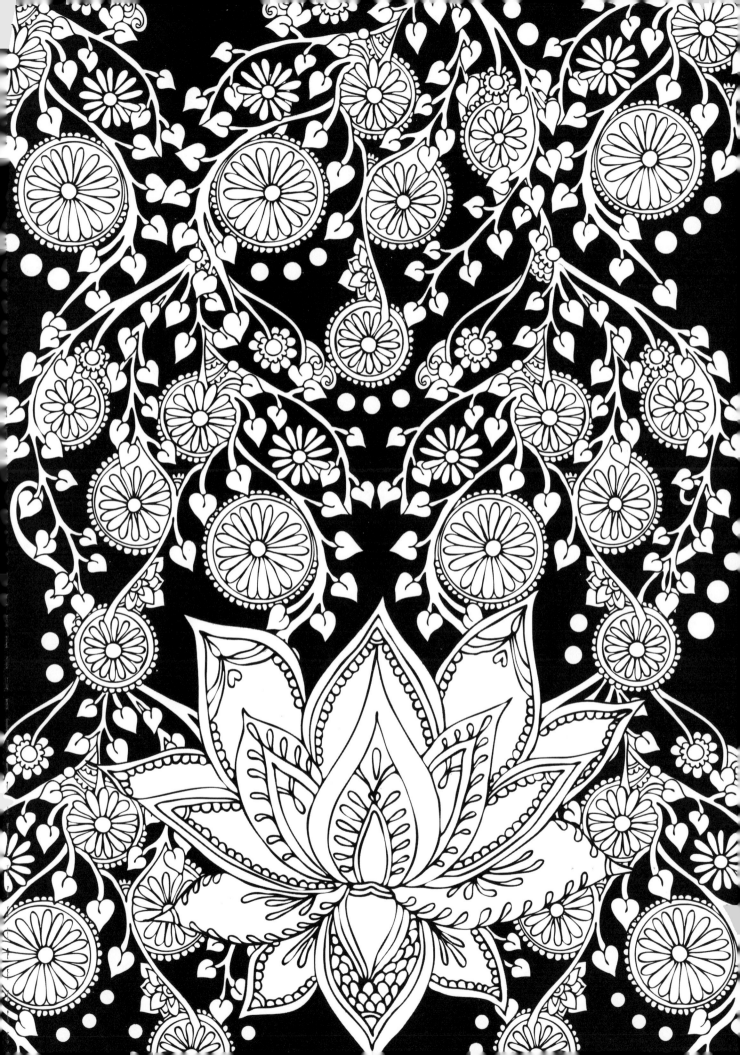

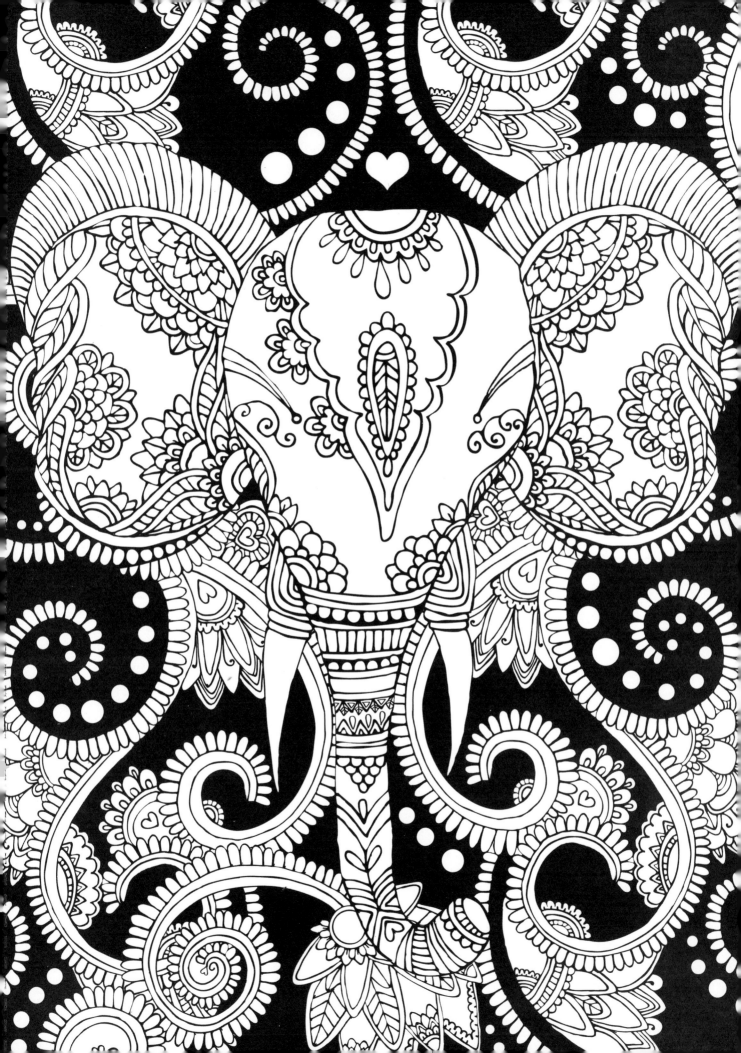

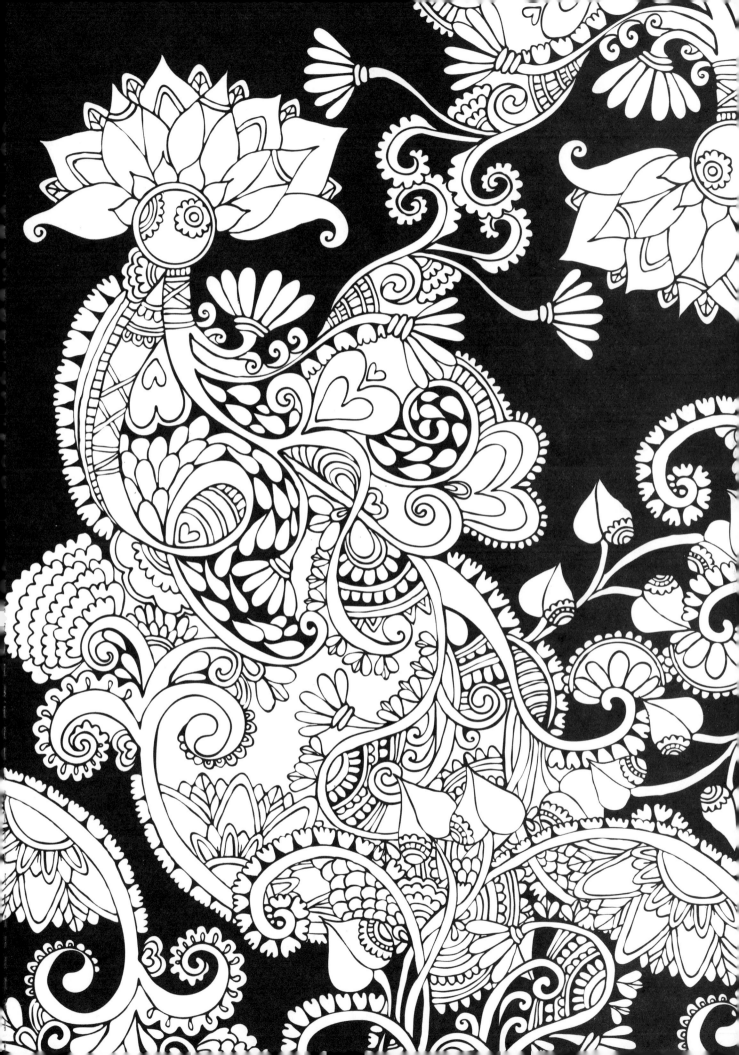

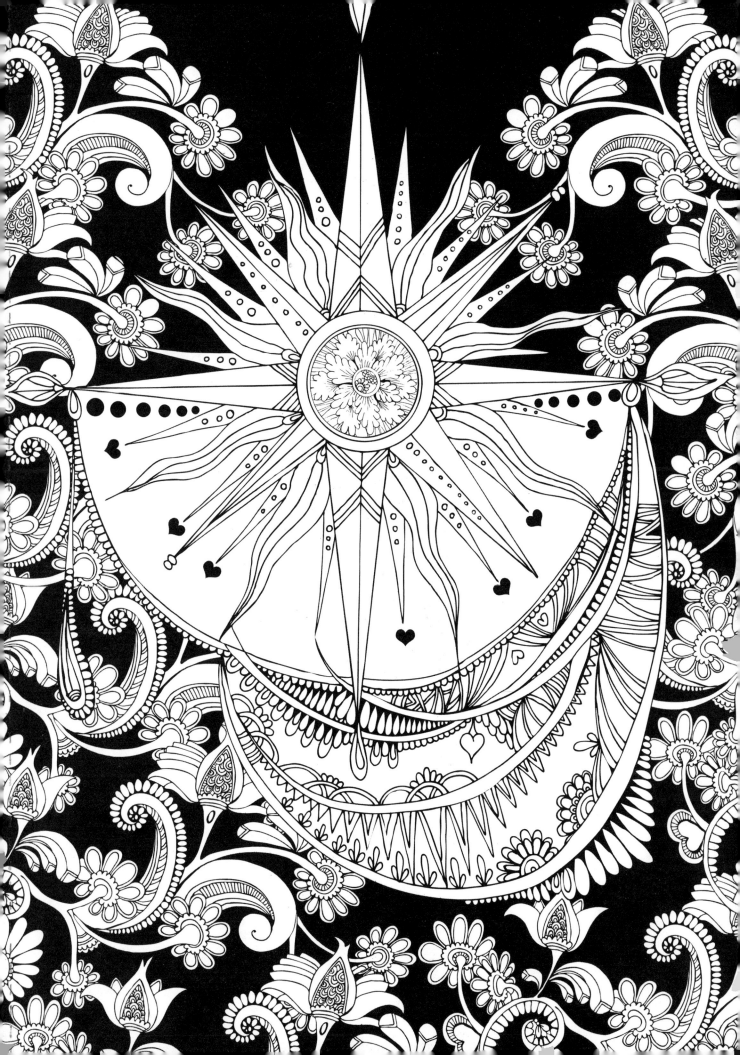

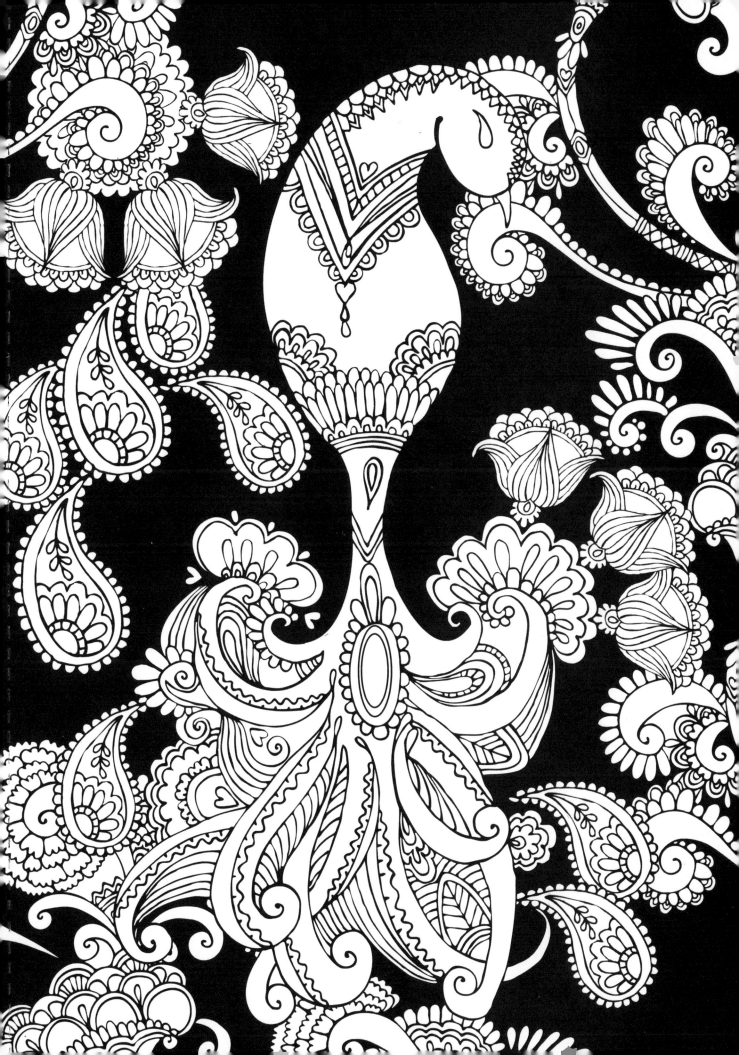